ERIC PAYSON GHOSTPLAY

pH **powerHouse Books** New York, NY

For Blake Hines

Ghostplay is the third part of a trilogy of books by Eric Payson, beginning with *Bobcats* (powerHouse, 2002) and followed by *Gladiators* (powerHouse, 2004), which I have been fortunate enough to edit.

Bobcats, a photo document of a girls softball team from Arizona, displayed a rite of passage for the adolescent athletes that was both balletic and graceful, yet imbued with the release of hormones. The softball pitch served as a scaled-down teenage stadium.

Gladiators took the viewer to major league basketball photographed from the television. What appeared as combat seemed to be conducted in a pit of racial divide. Most of the players were black and most of their management and the spectators were white. The game produced the most extreme expressions in the faces of the players. A heroic and deadly serious encounter was frozen, not unlike newsreel footage, in the flicker of the screen.

Ghostplay takes us to another arena. College football is caught off the screen. The play is introduced by the pundits, interspersed with news bulletins, beer commercials, cheerleaders, anxious spectators, and data on the combatants' injuries. The game dissolves into the ghost imagery that lies between the frames of the broadcast. This is where the action lies. The beauty of the work is in the abstraction and flow of the players' gestures. The disarming resonance of this image-flicker is like that of the fertile period of the imagination when the brain hovers between consciousness and sleep. It is then that the deeper patterns of the subconscious rise to semi-conscious, half-remembered truths. This is a book about what goes on between the lines. The story is one of disjunction leading to a score. It is not a book about college football.

Mark Holborn

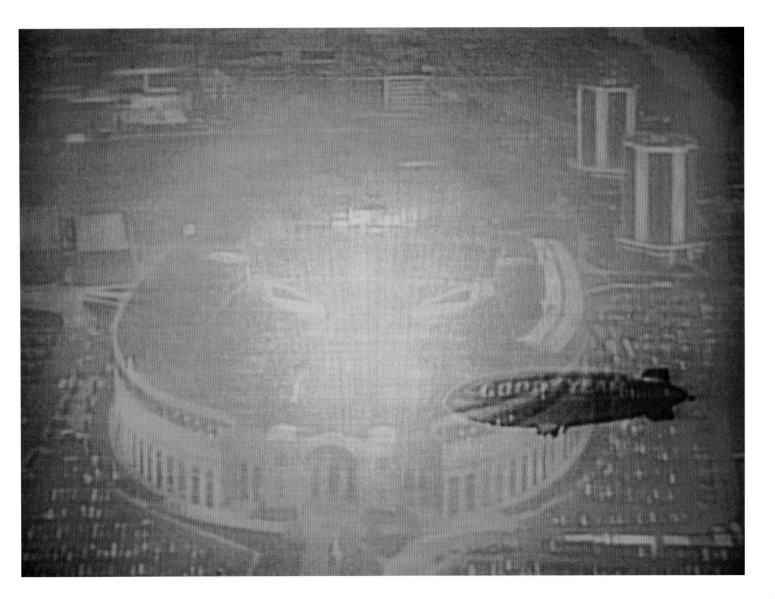

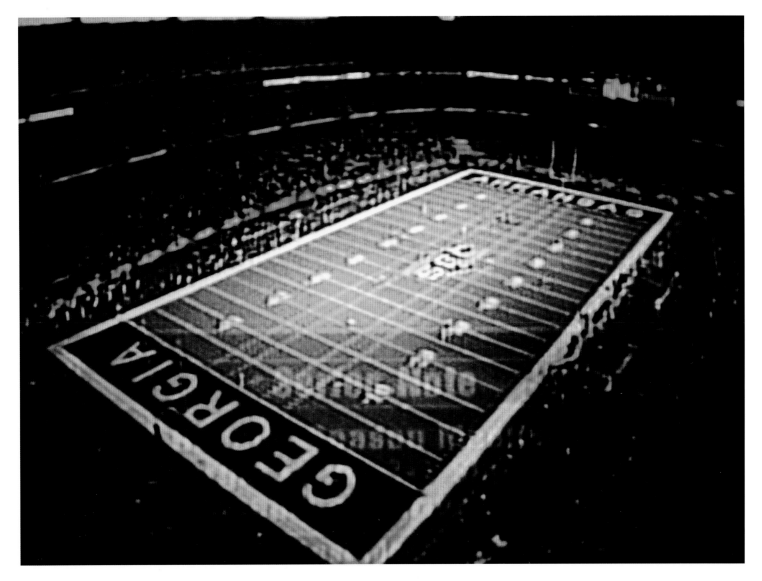

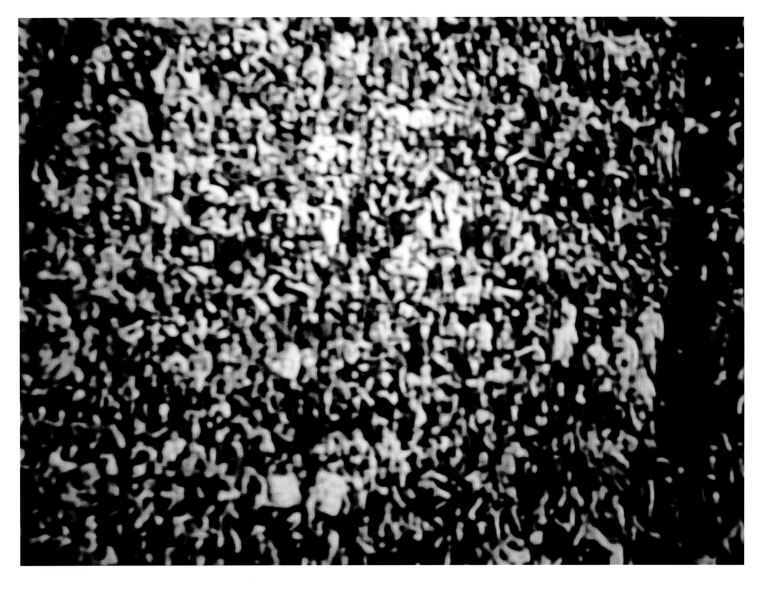

Battered Bulldogs

GEORGIA PLAYERS WHO HAVE MISSED ACTION

Player	Injury	Time Out
Terrence Edwards WR	Left Shoulder	Rest of Season
Damien Gary WR	Left Leg	3 Games
George Foster OT	Dislocated Right Wrist	4 Games
Russ Tanner C	Right Hand (Tendon)	5 Games
Nic Clemons DE	Turf Toe Clemson	6 Games
D.J. Shockley QB	Broken Left Foot	4 Games
Musa Smith RB	Left Thumb Fracture	1 Game
Jon Stinchcomb OT	Left Knee	1 Game
Fred Gibson WR	Left Thumb	2 Games

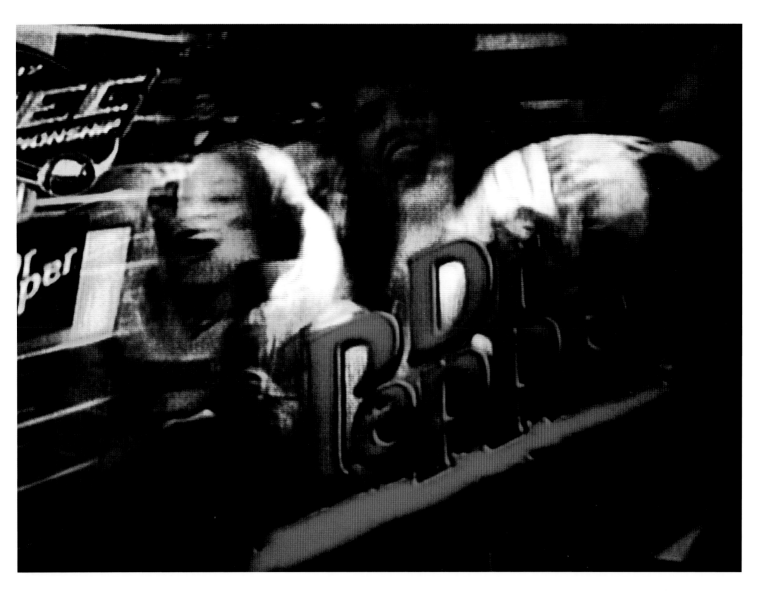

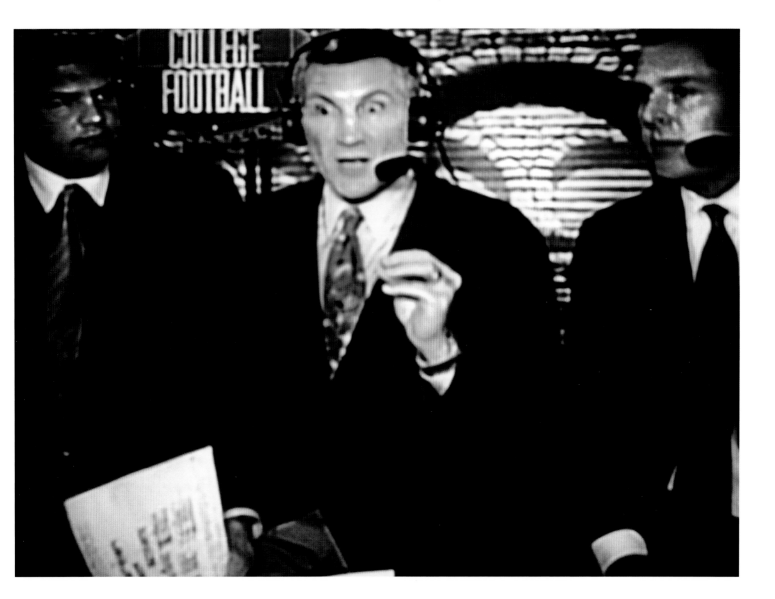

.

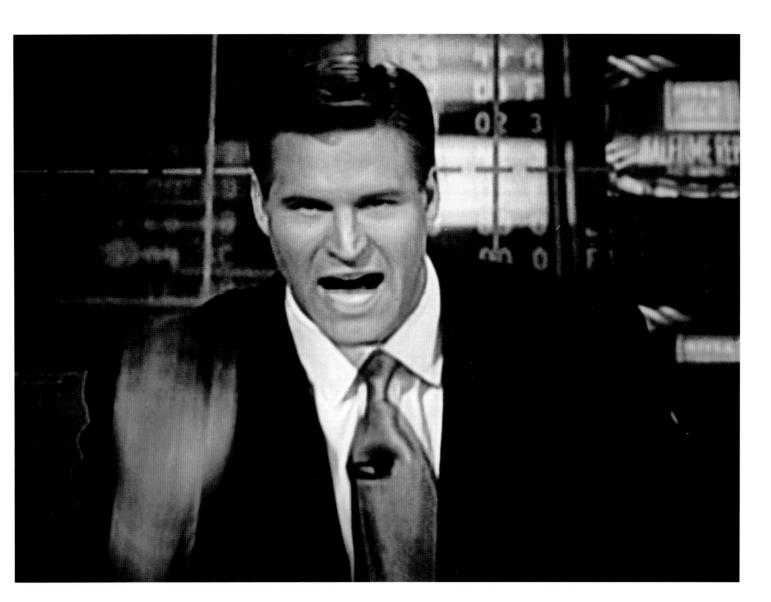

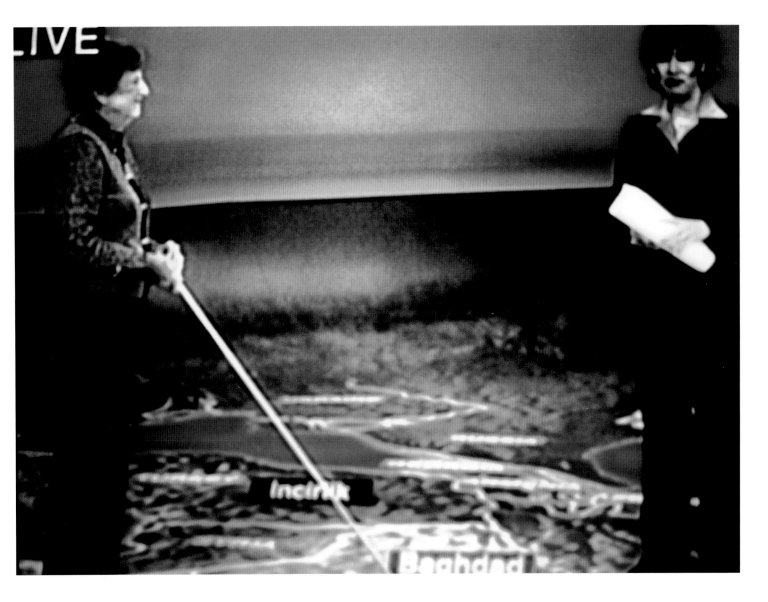

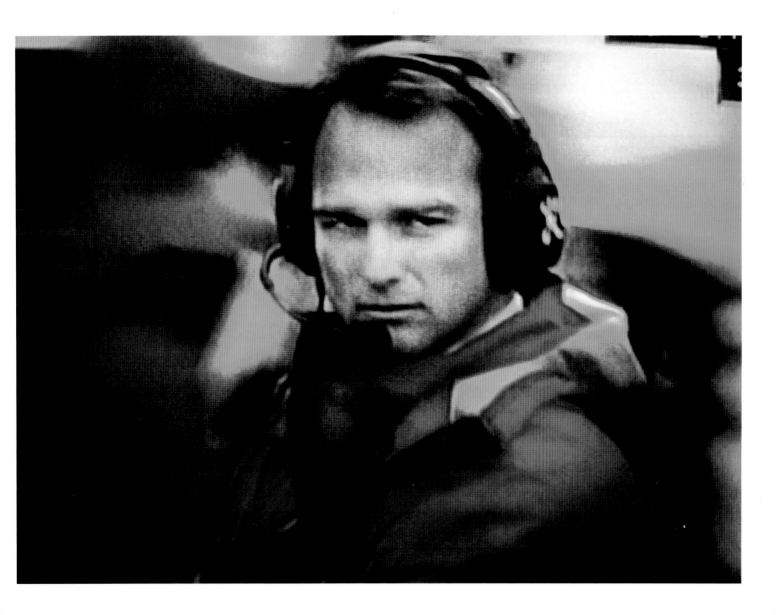

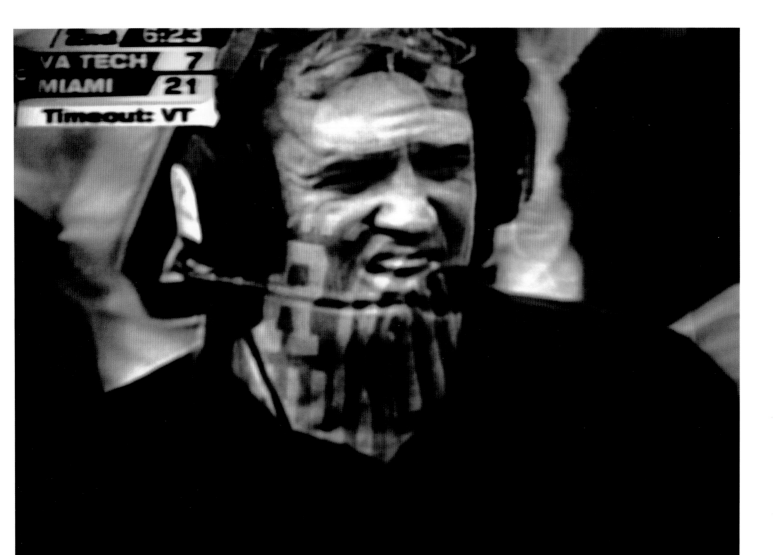

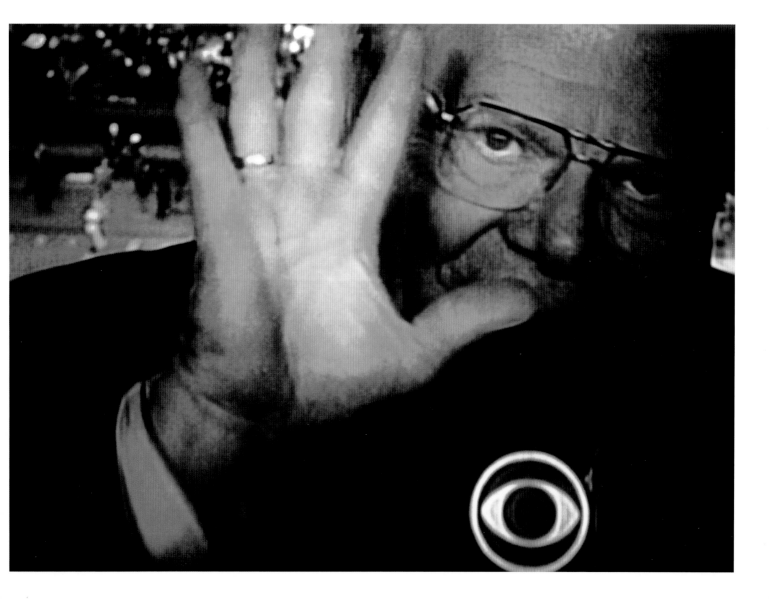

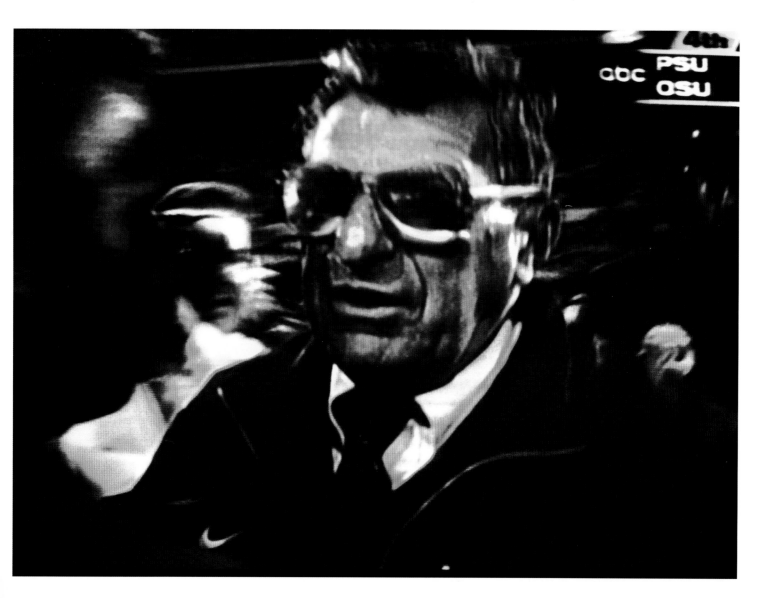

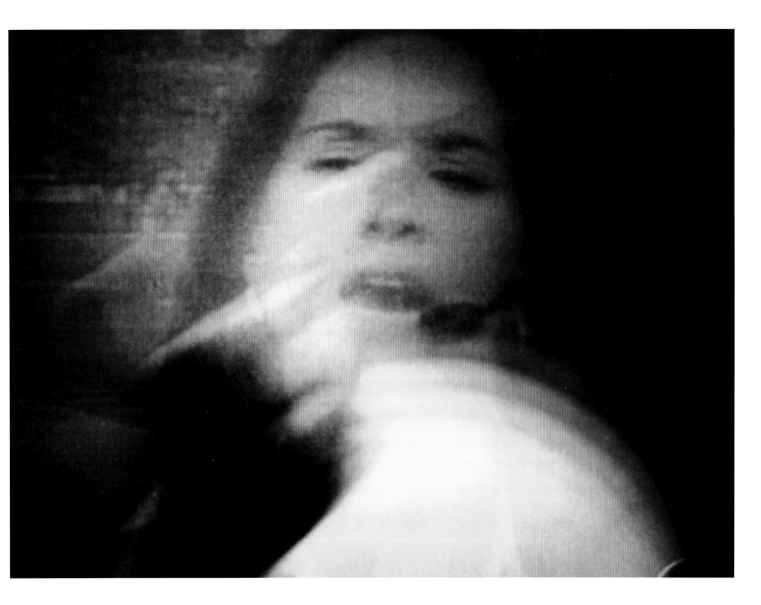

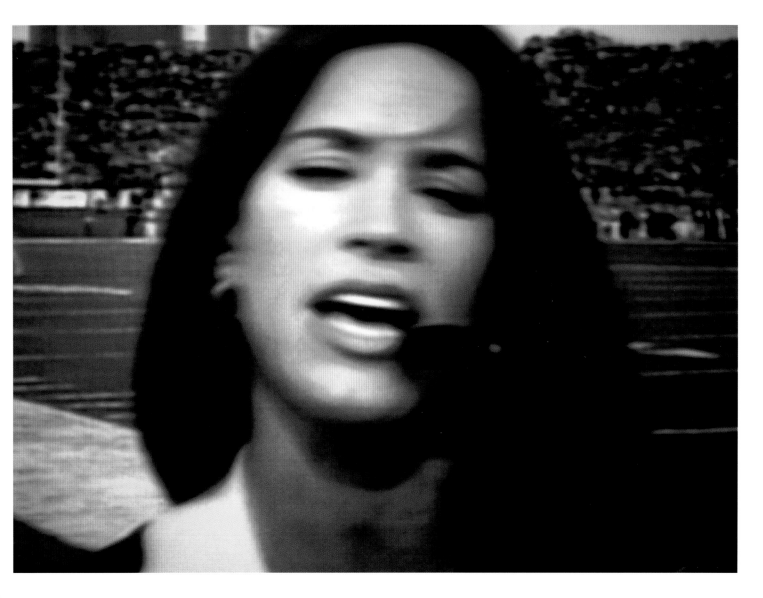

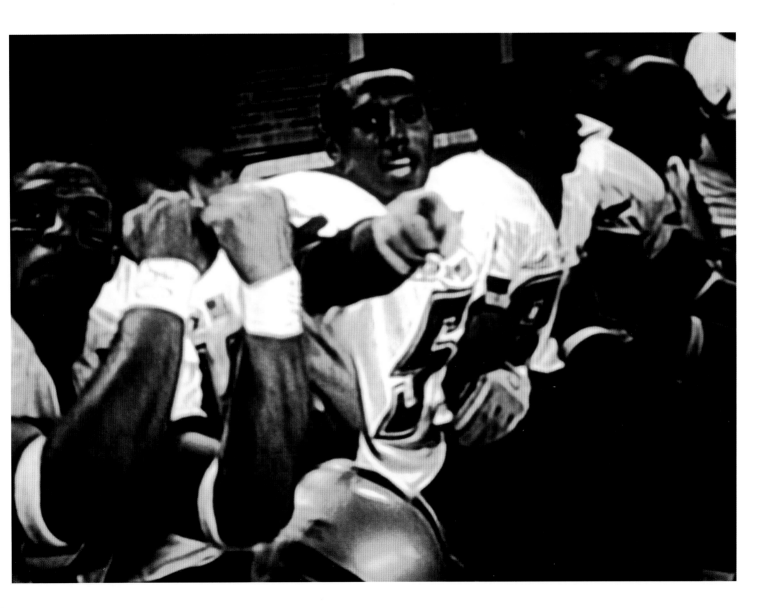

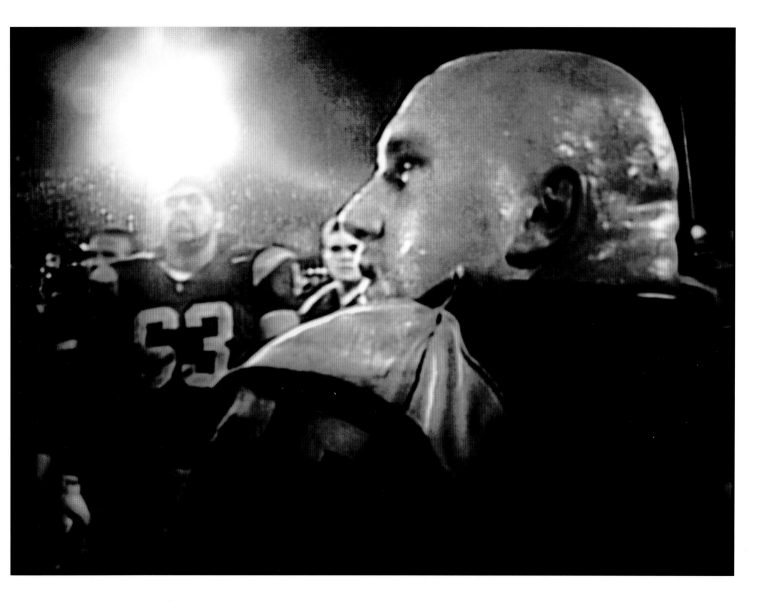

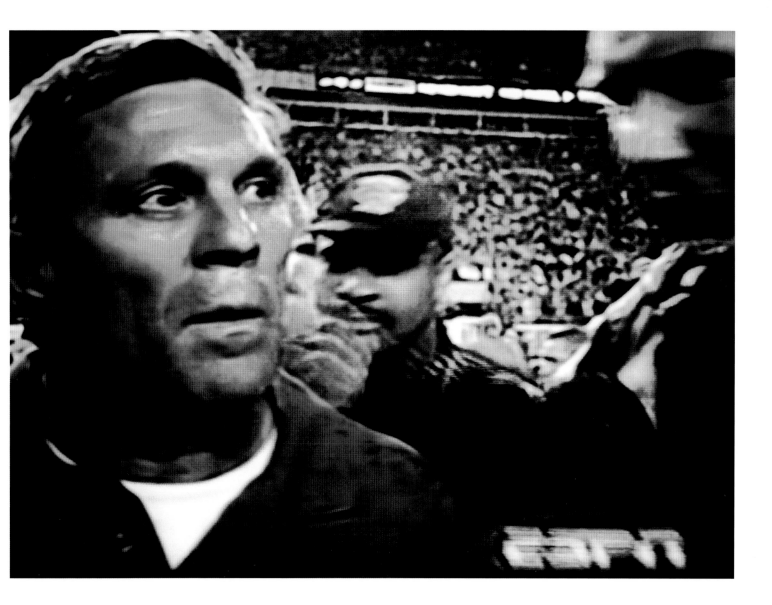

UGA VI

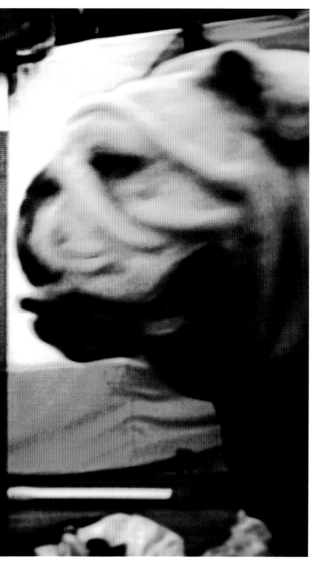

Univ. of Georgia Mascot

- heaviest in school history - 60lbs

- hometown: Savannah, GA

- kennel is fully air conditioned

- favorite human food: turkey

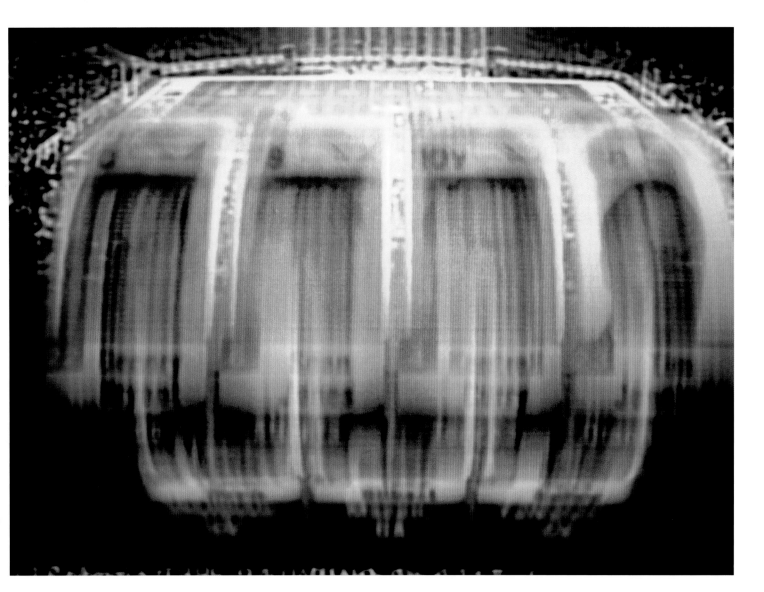

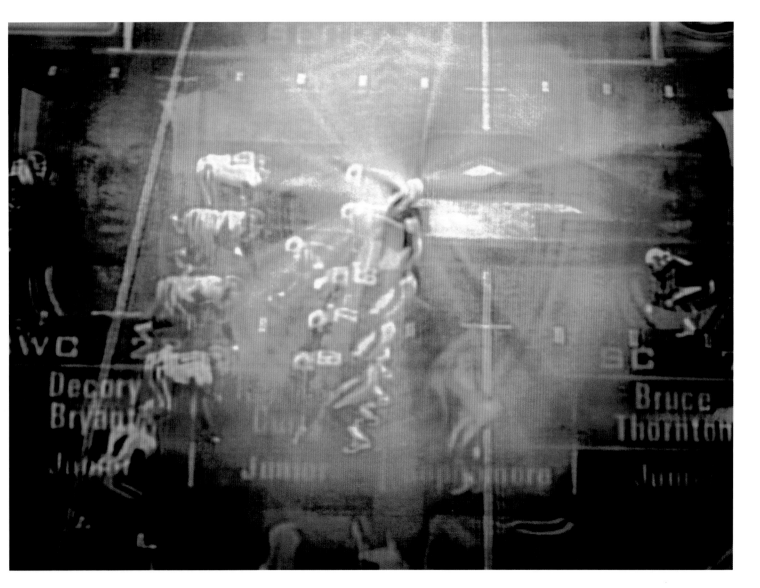

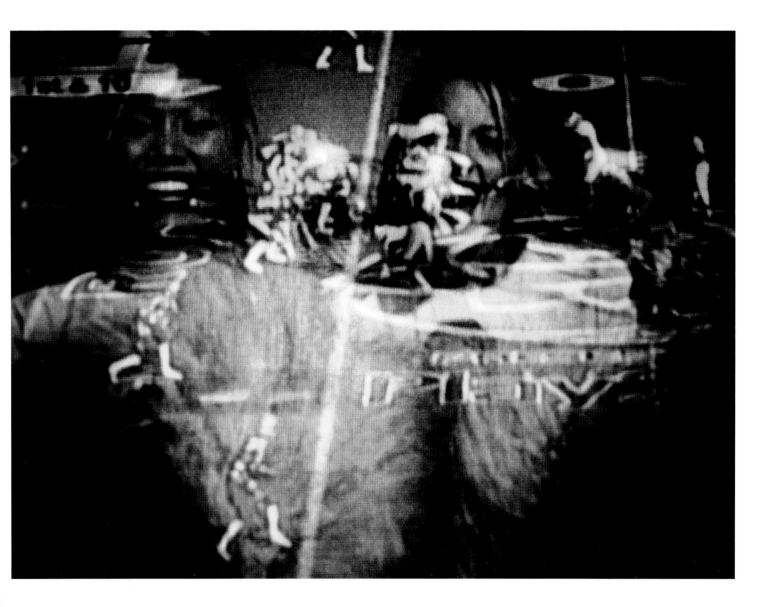

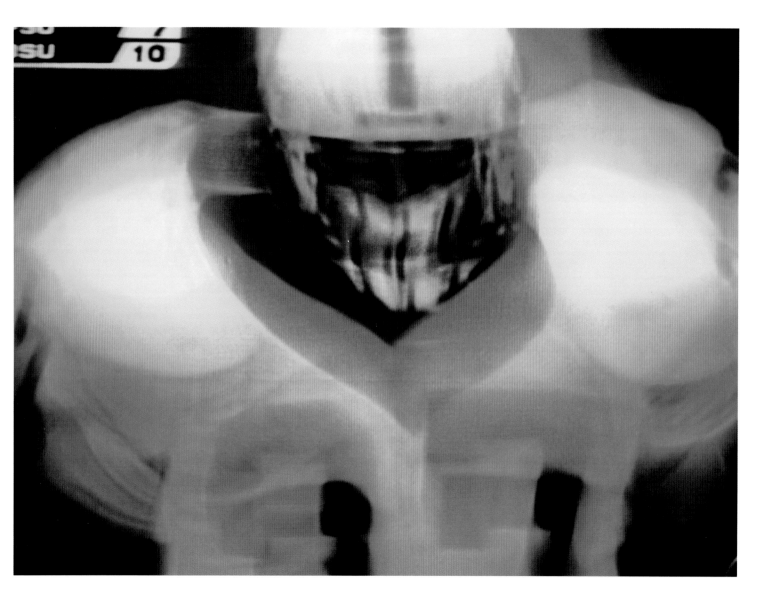

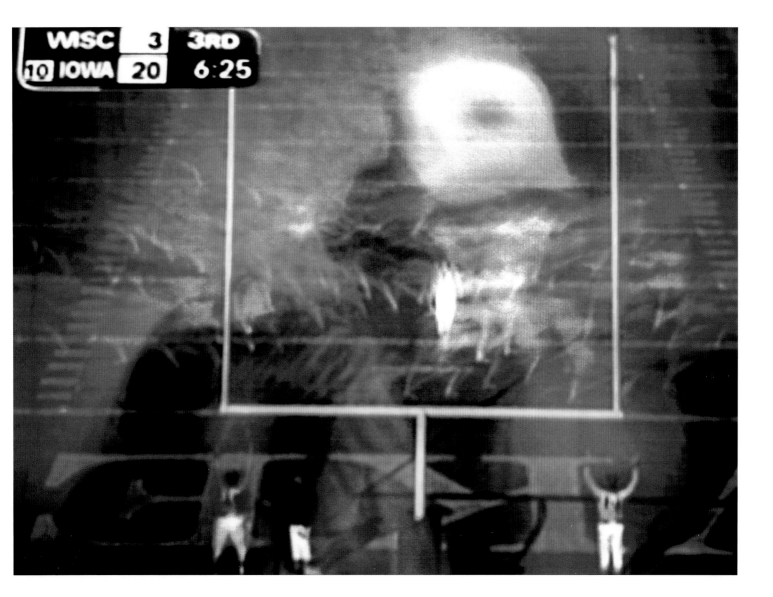

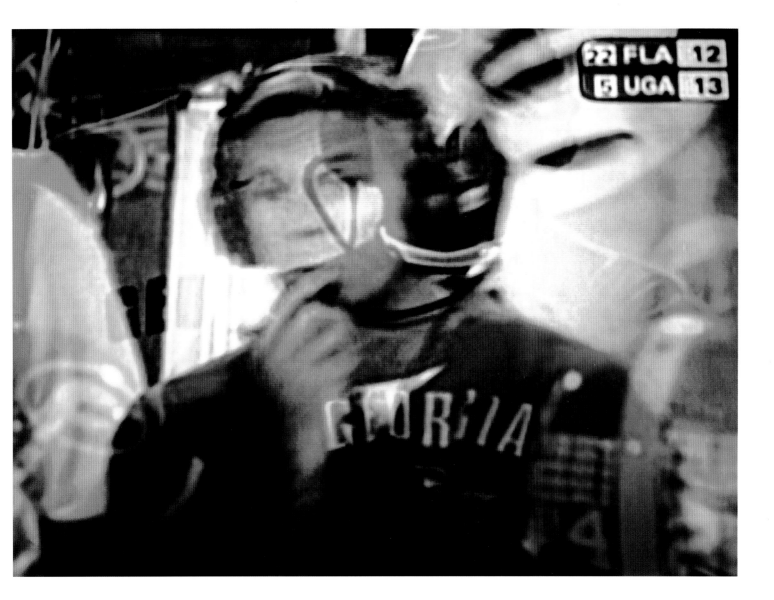

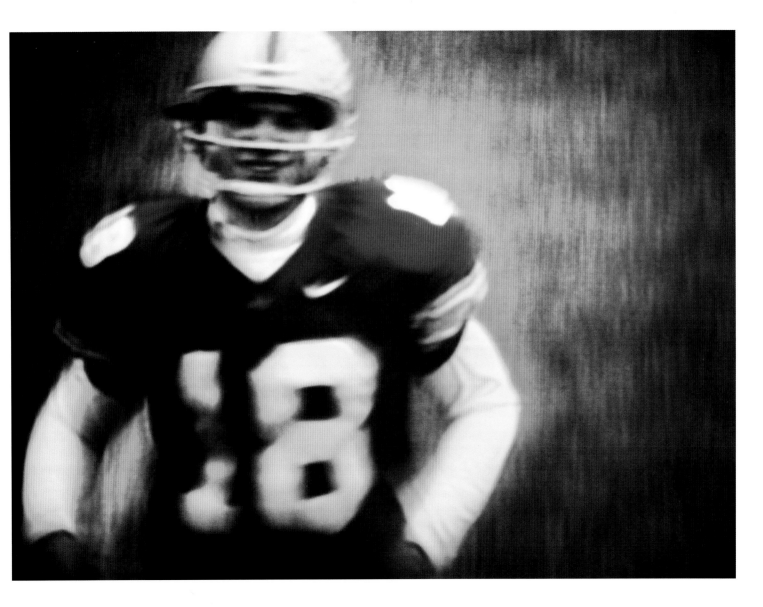

TIMEOUT: RU

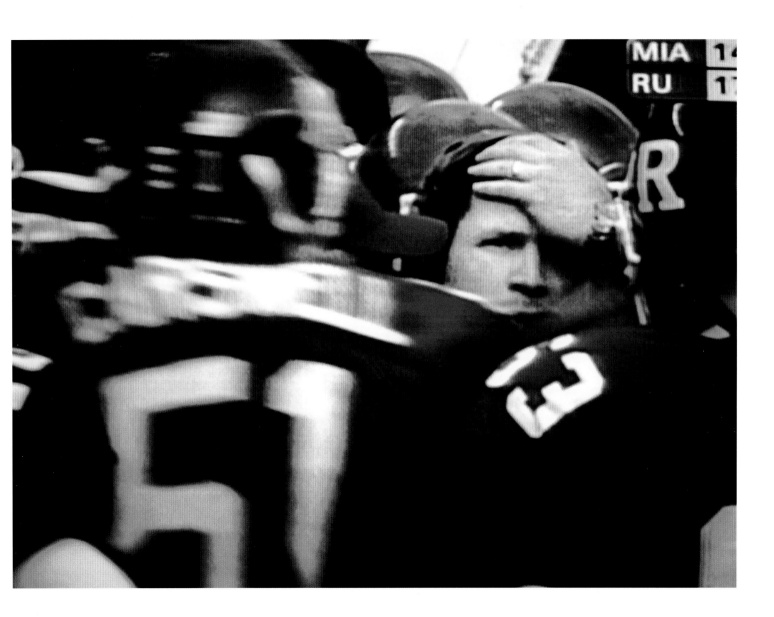

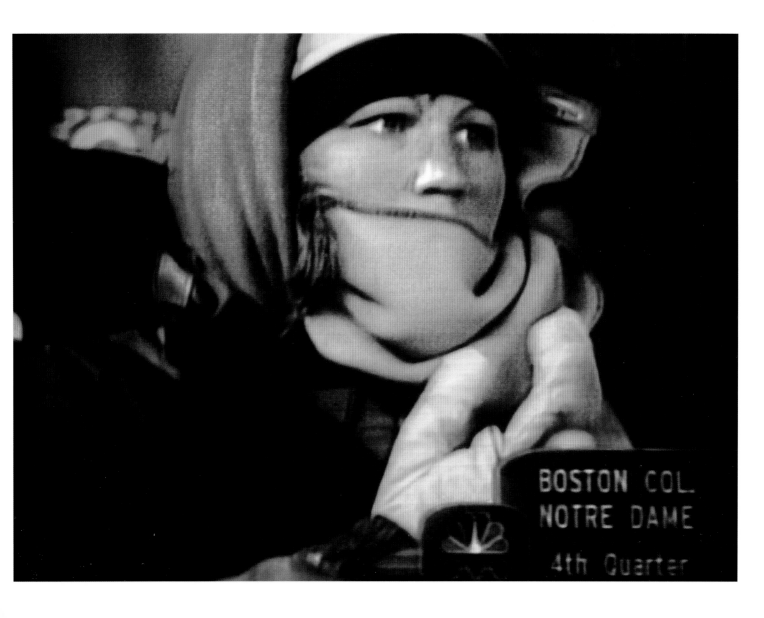

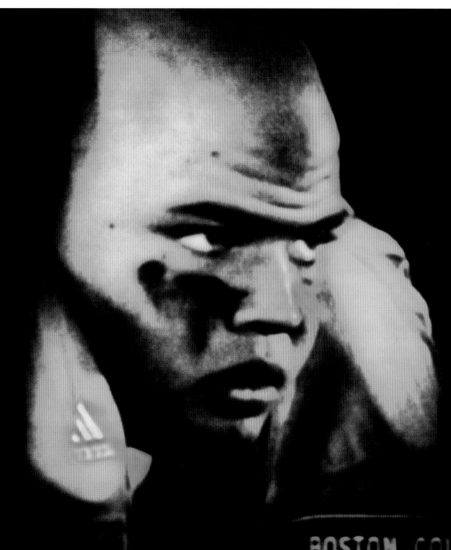

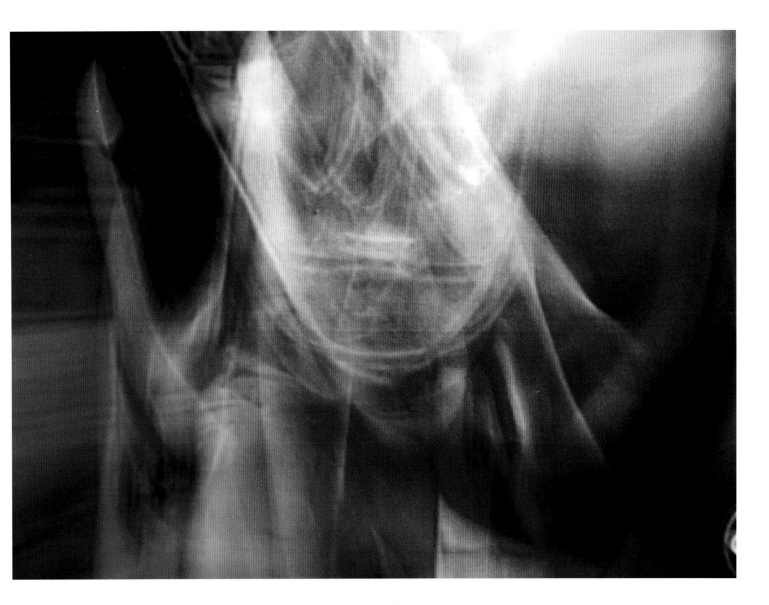

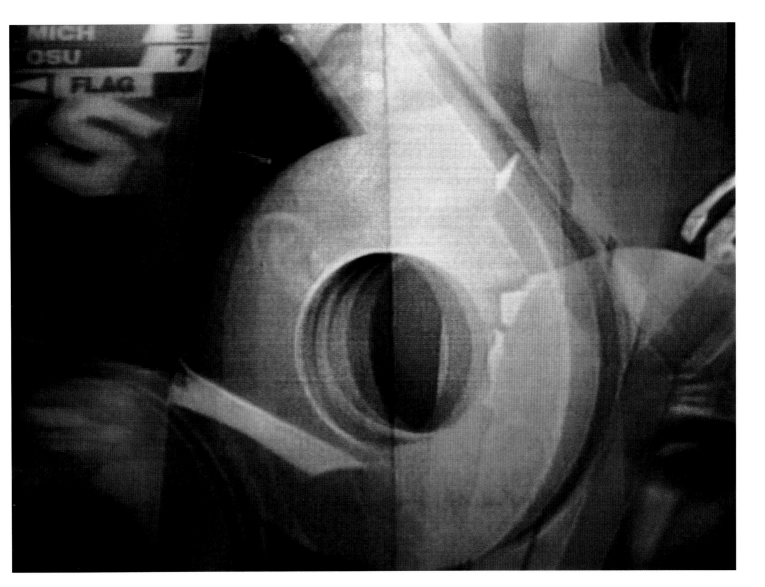

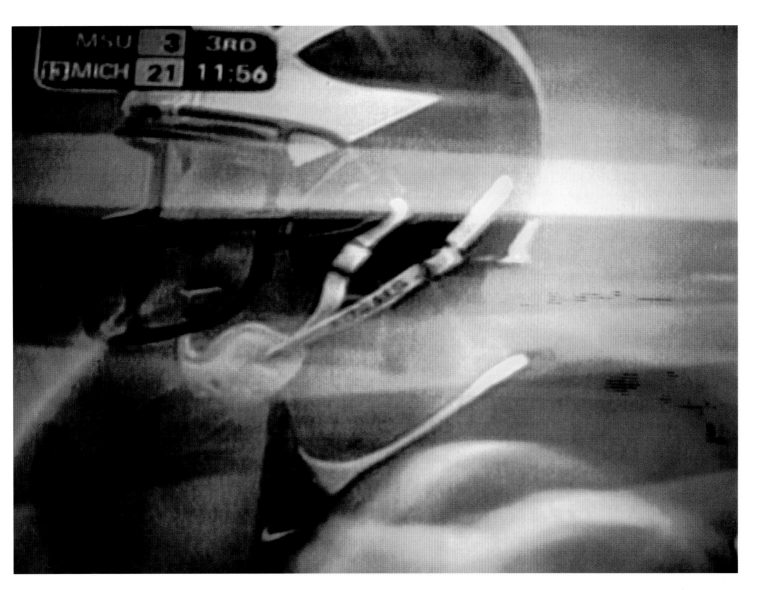

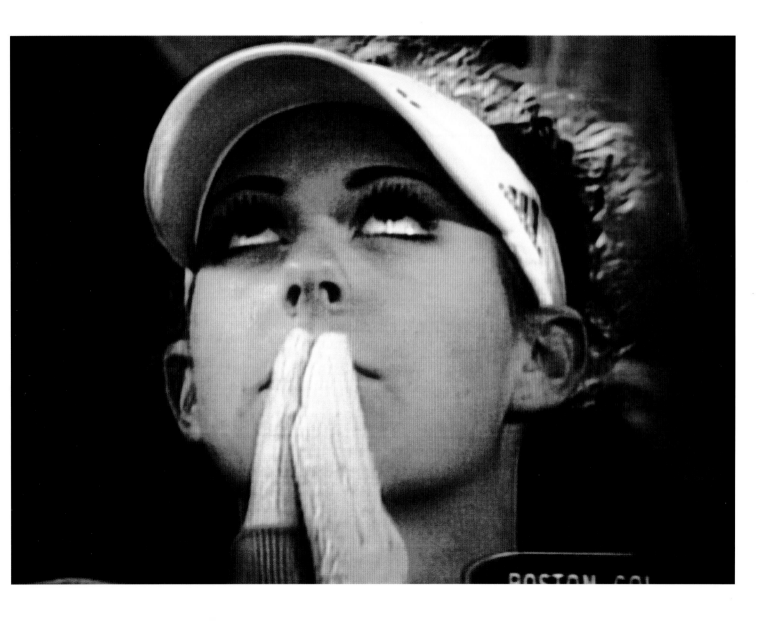

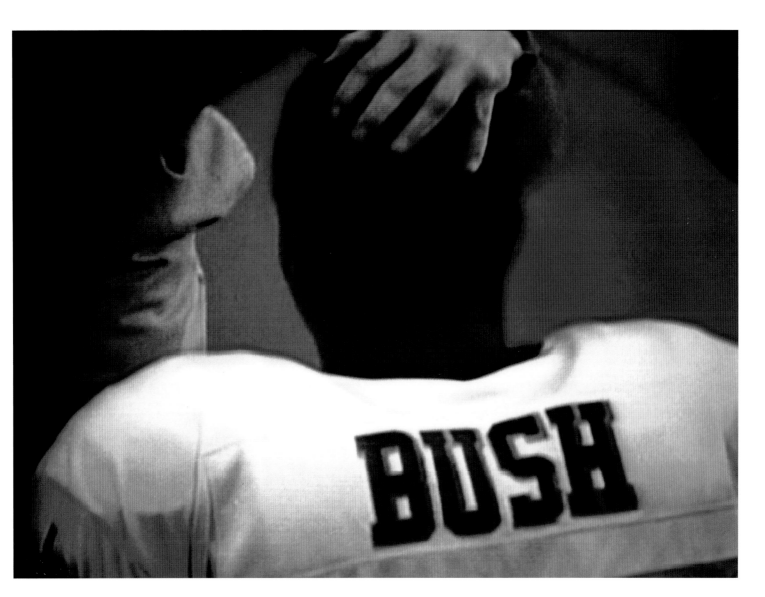

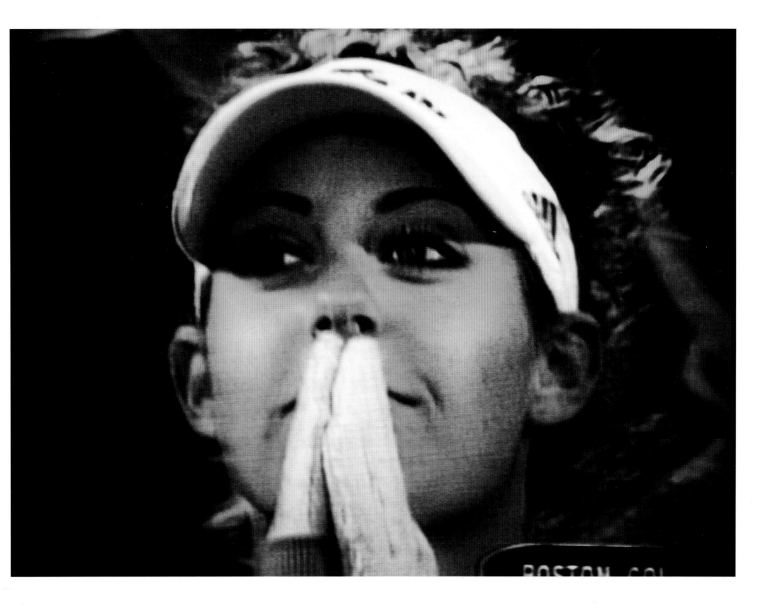

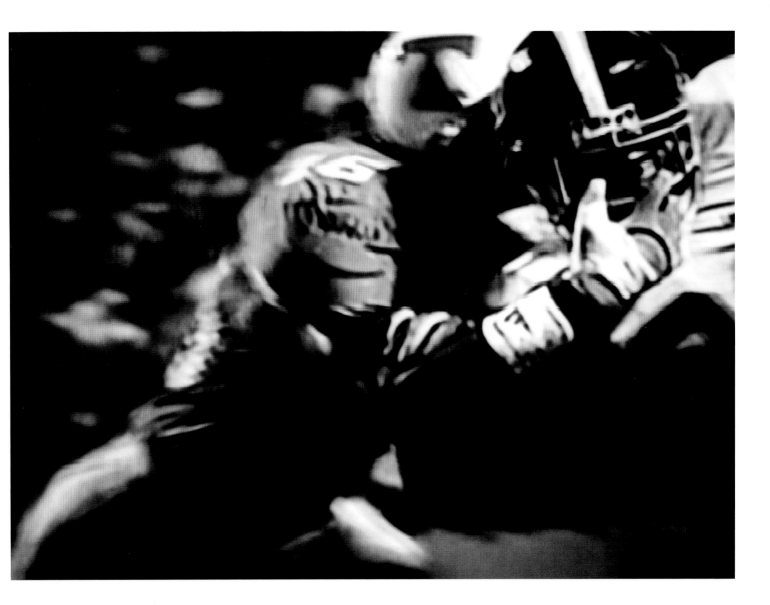

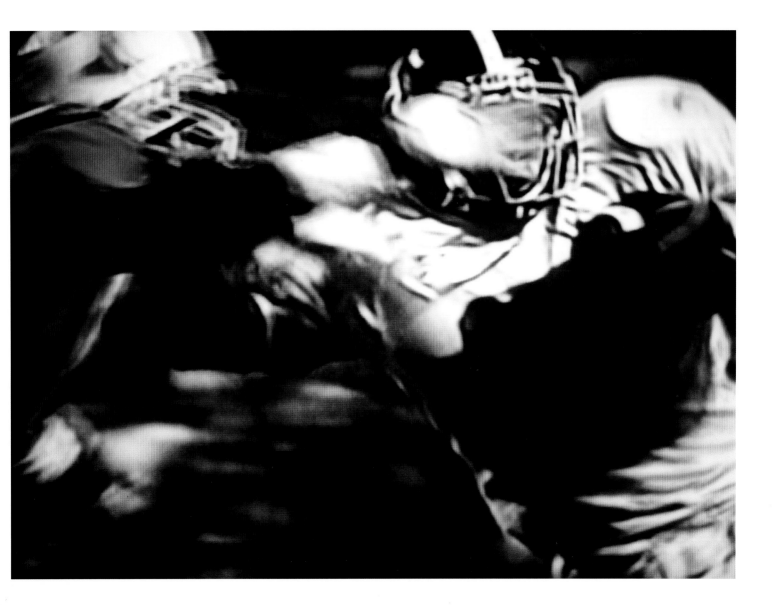

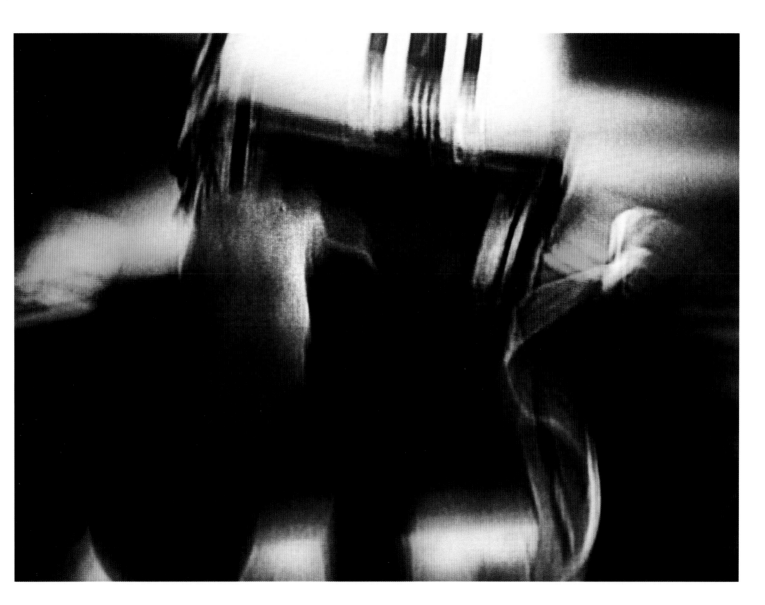

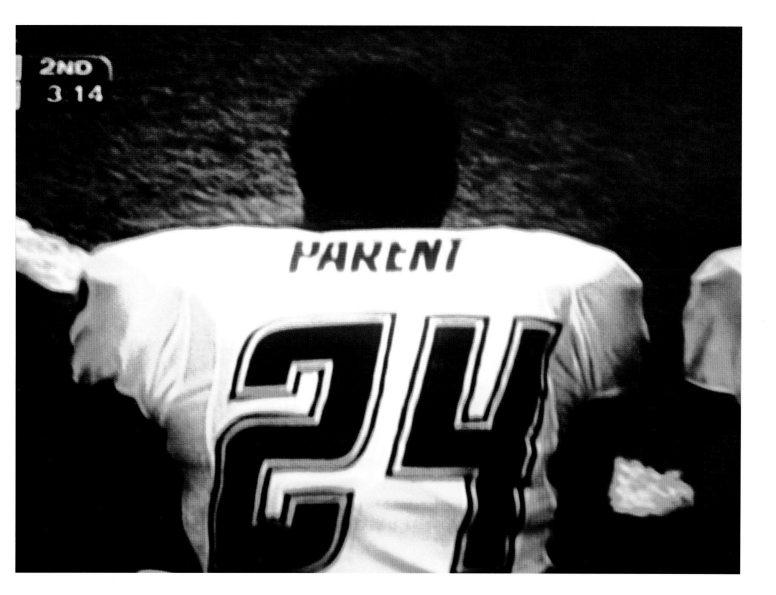

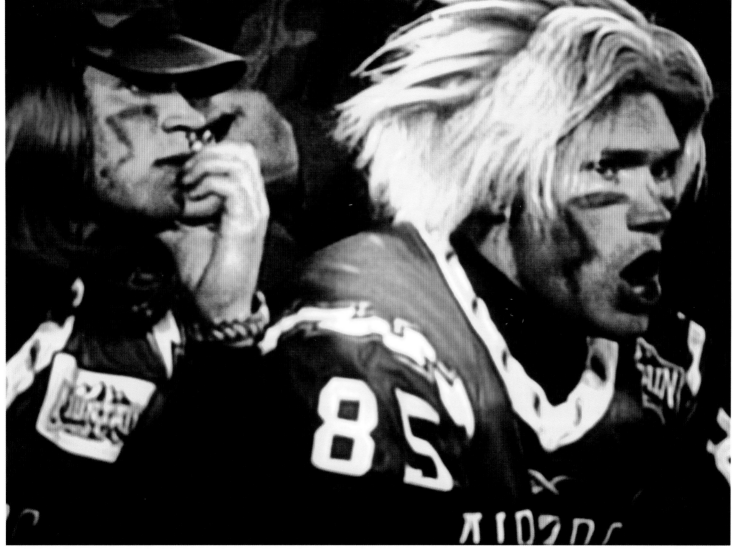

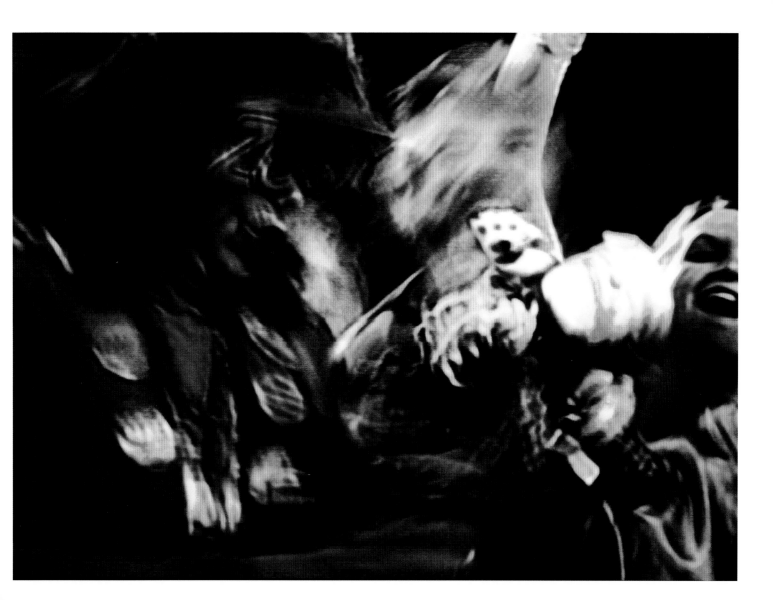

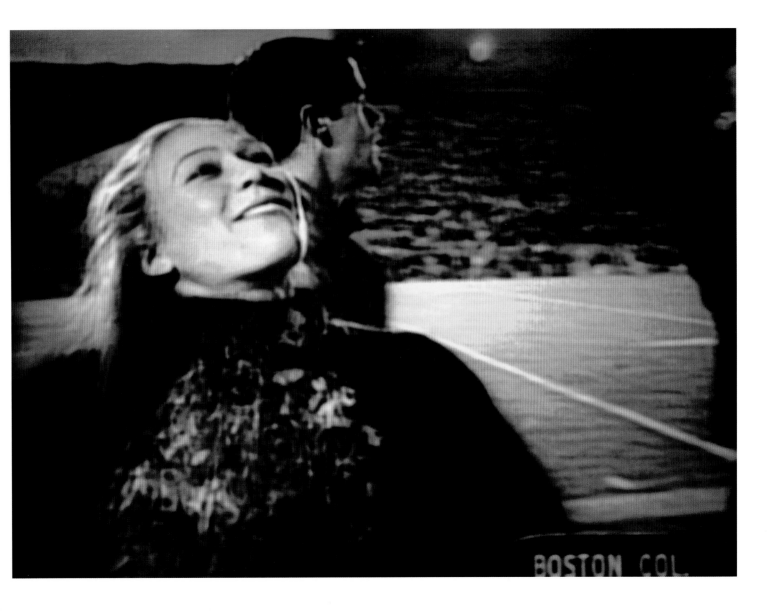

BOSTON COL.

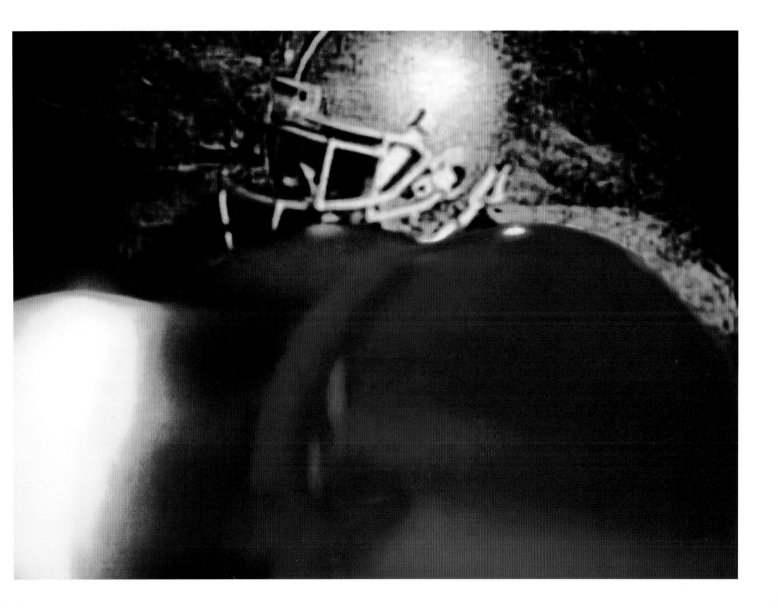

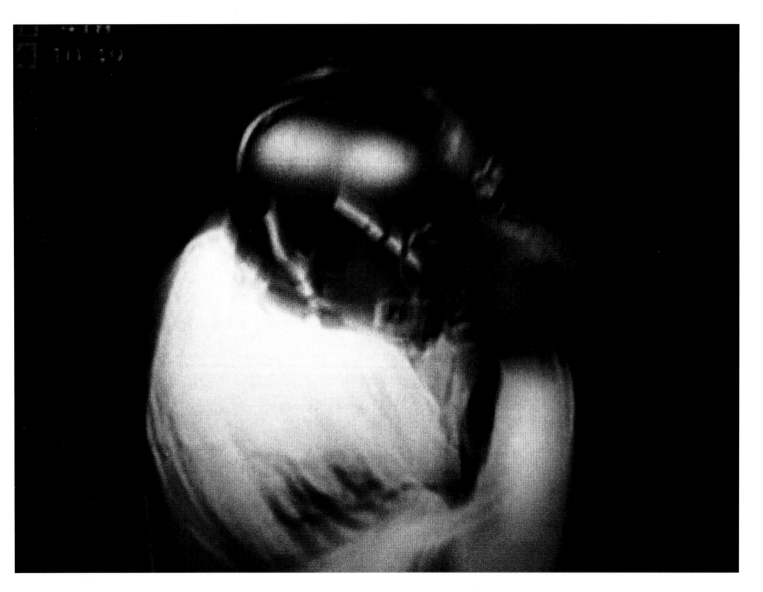

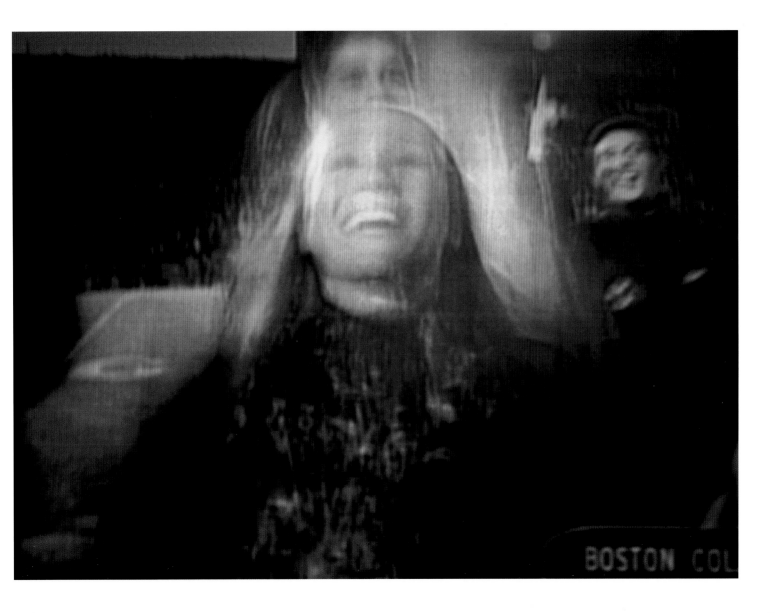

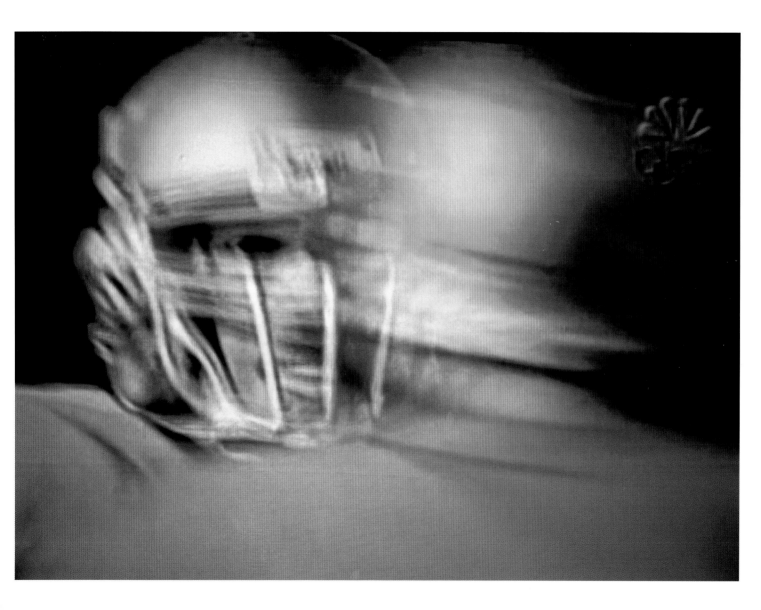

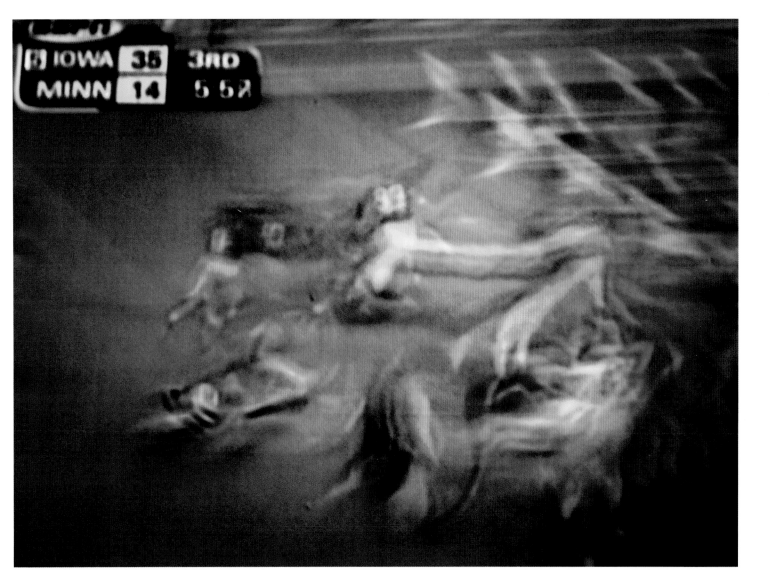

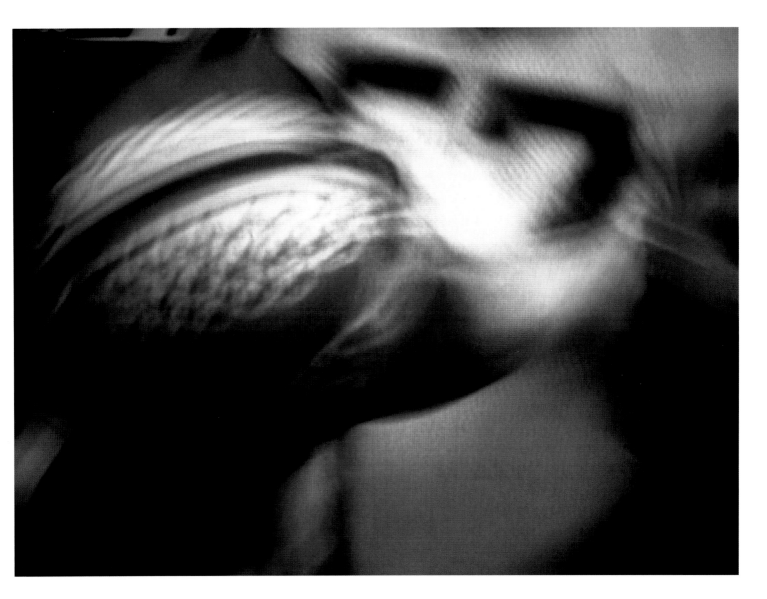

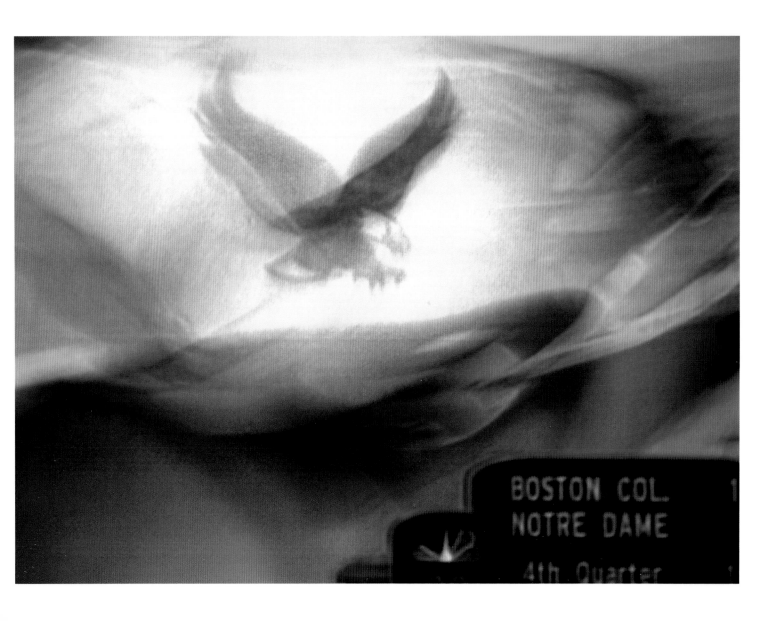

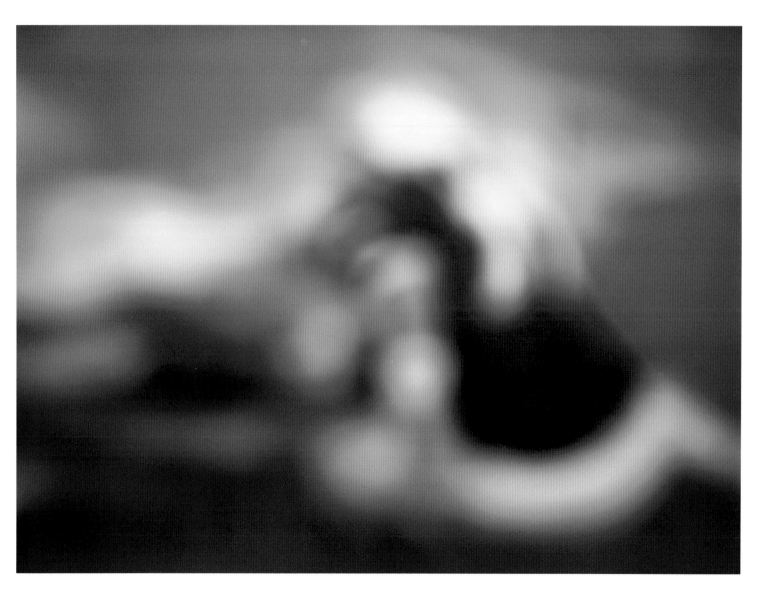

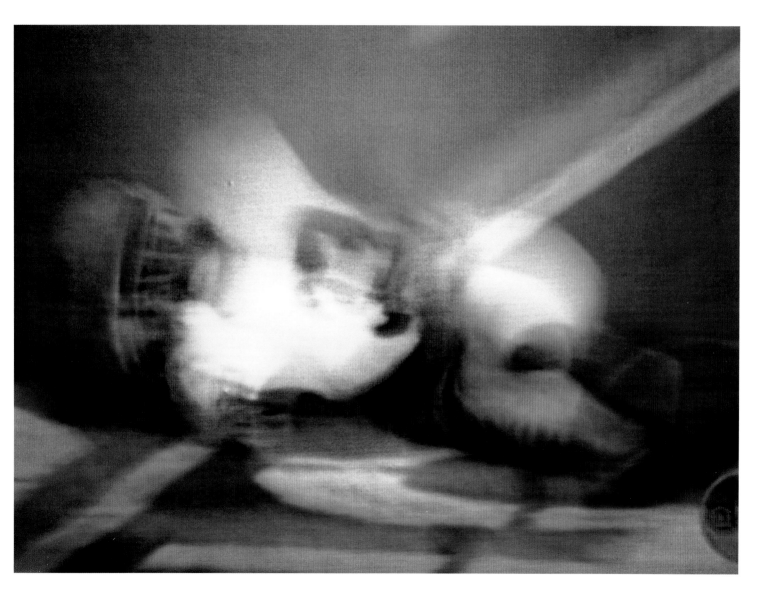

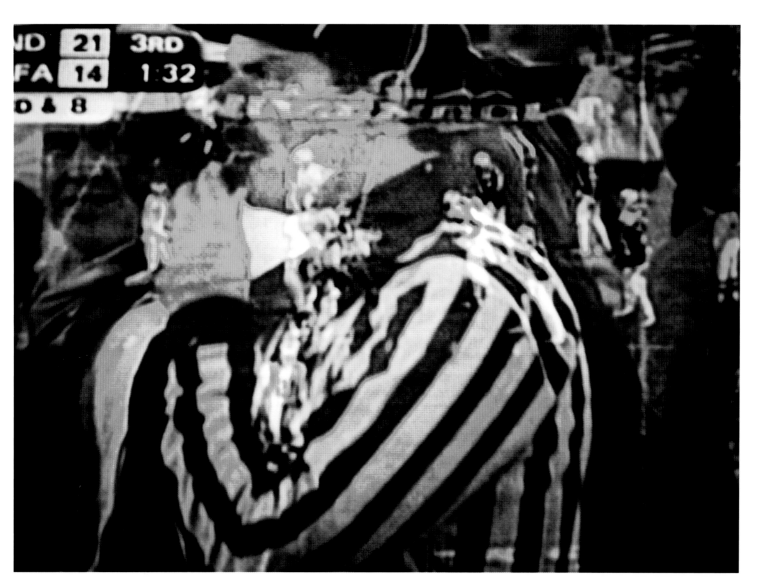

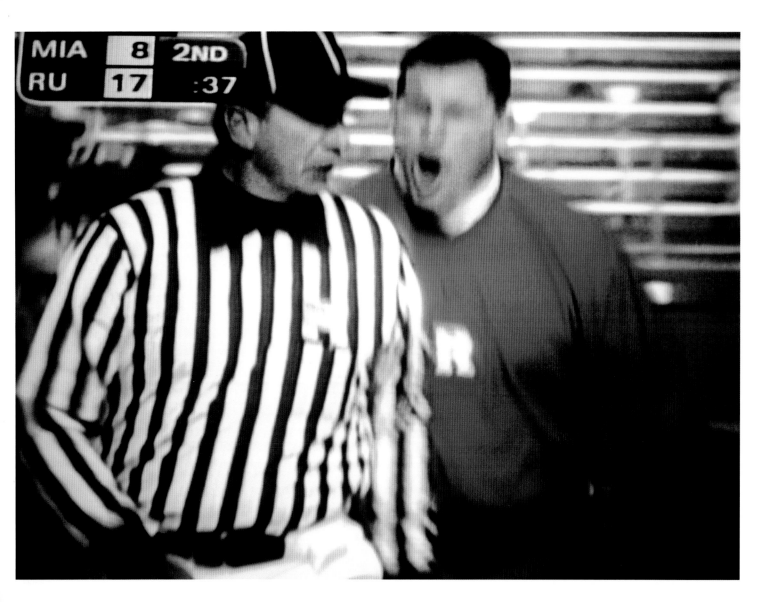

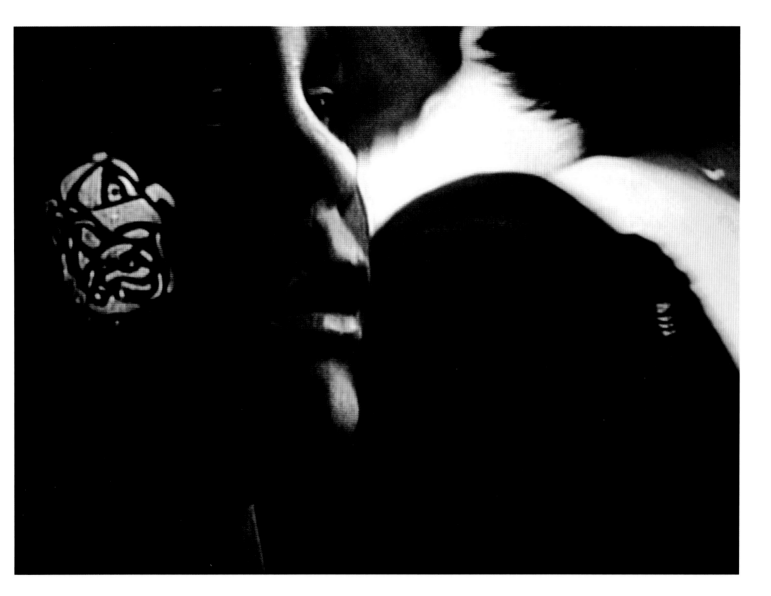

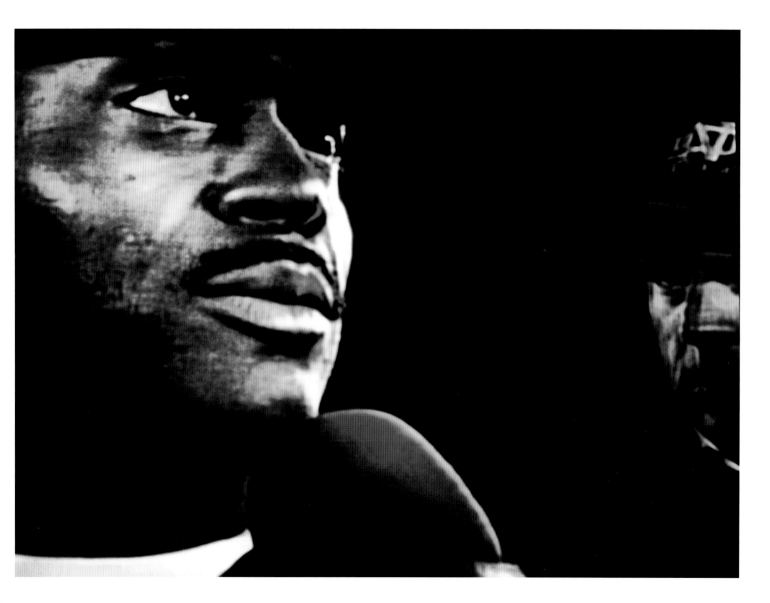

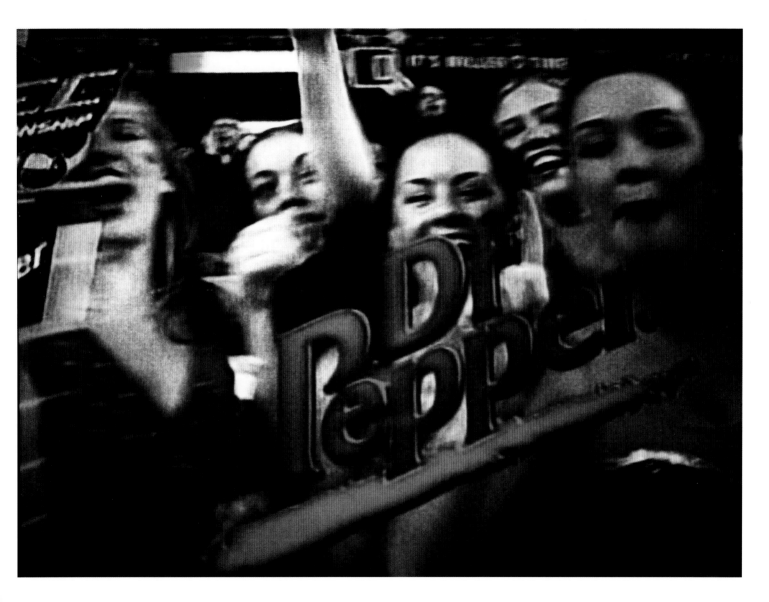

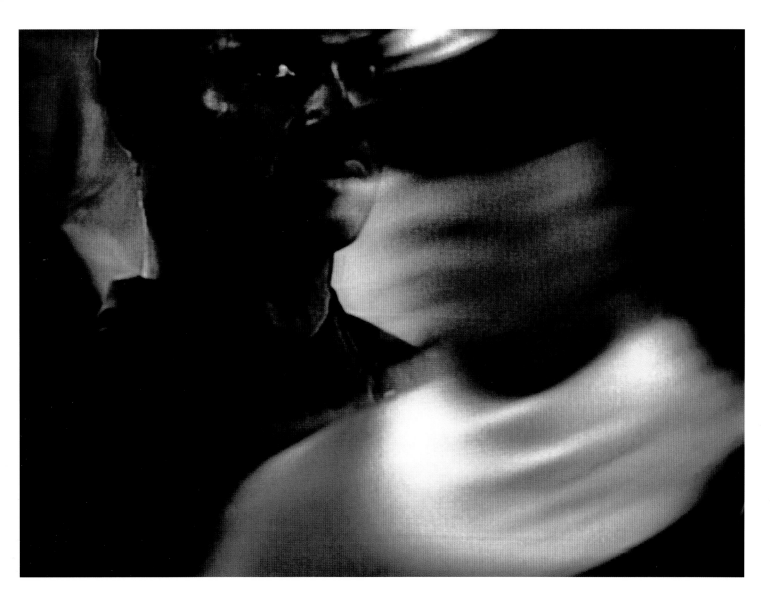

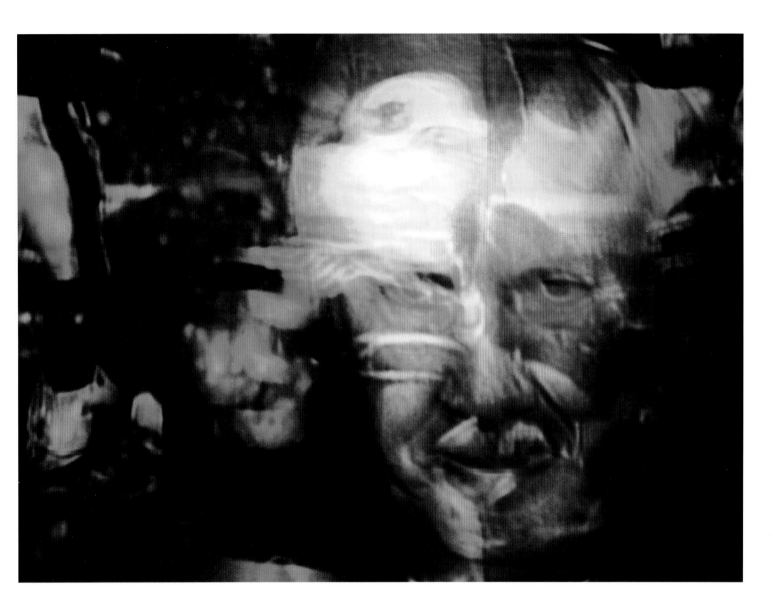

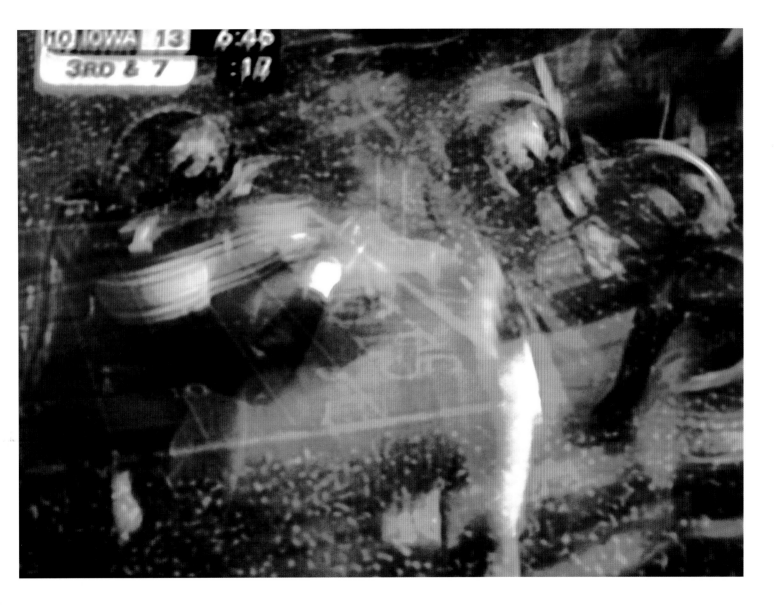

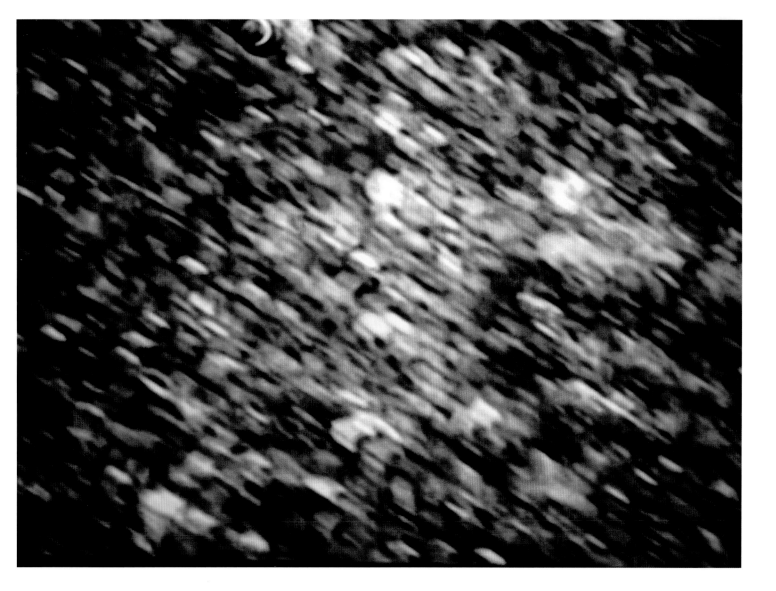

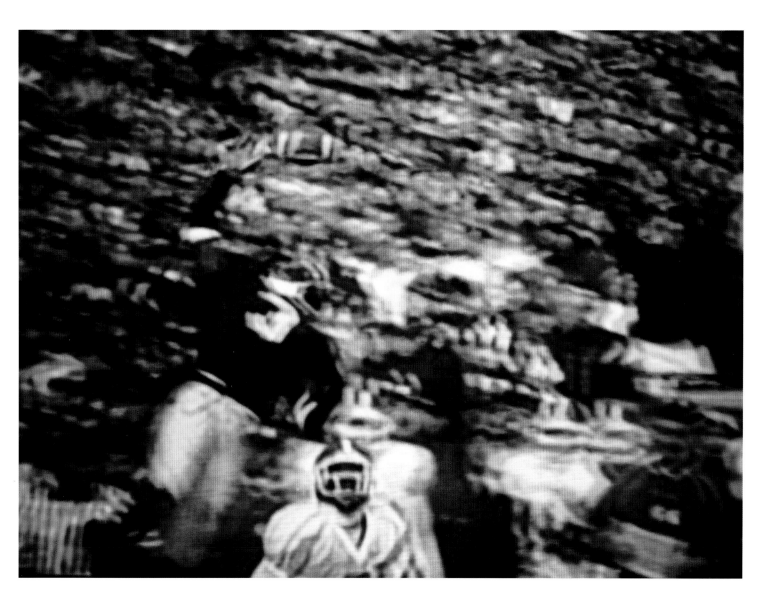

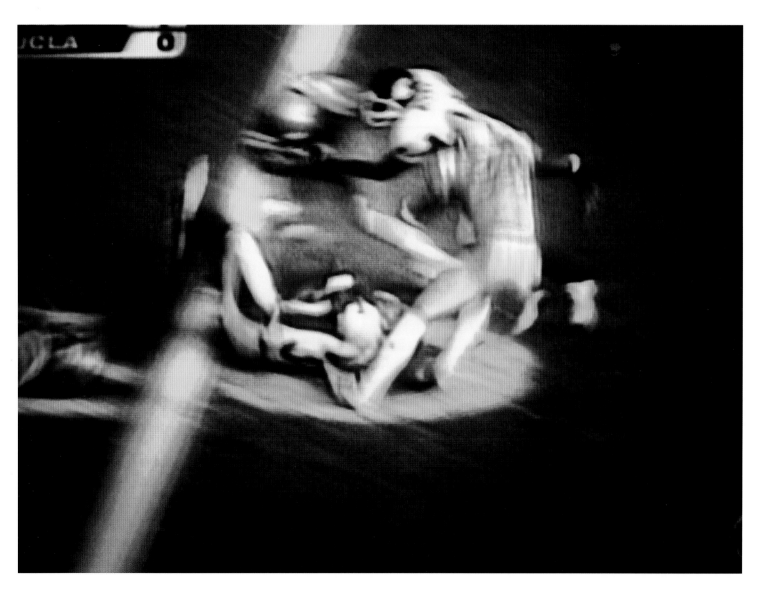

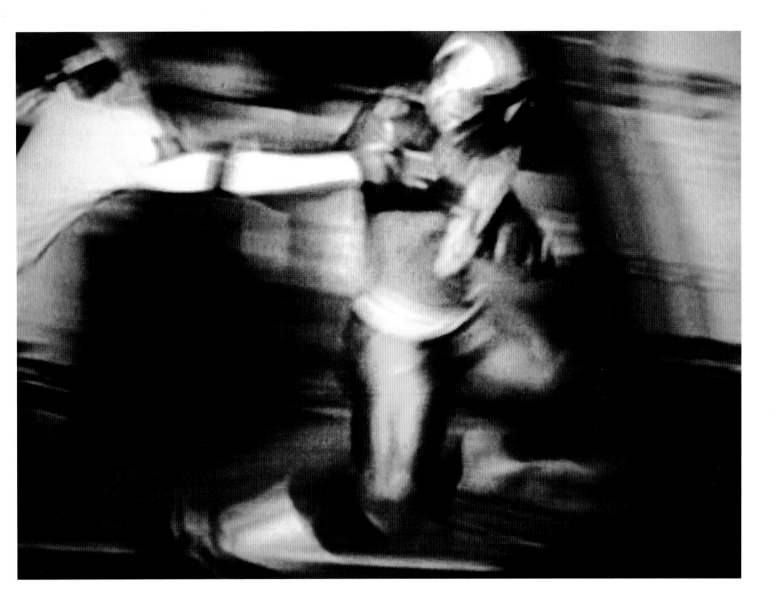

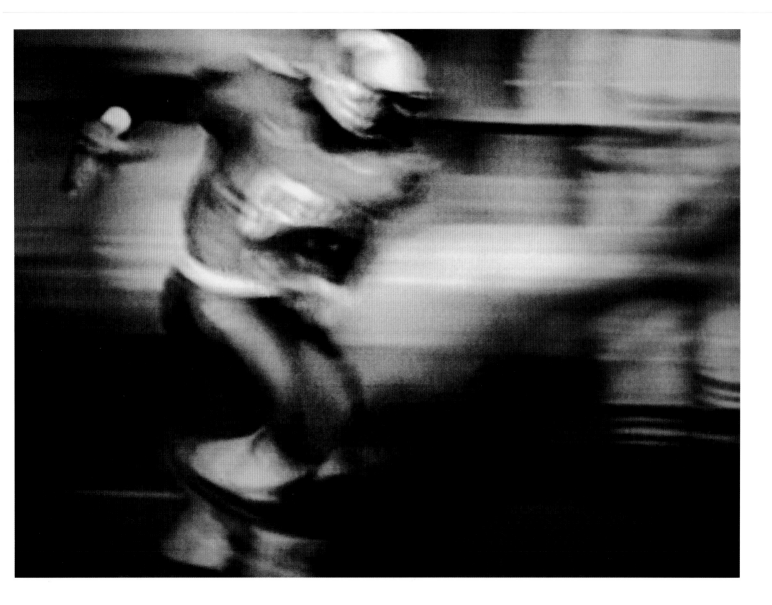

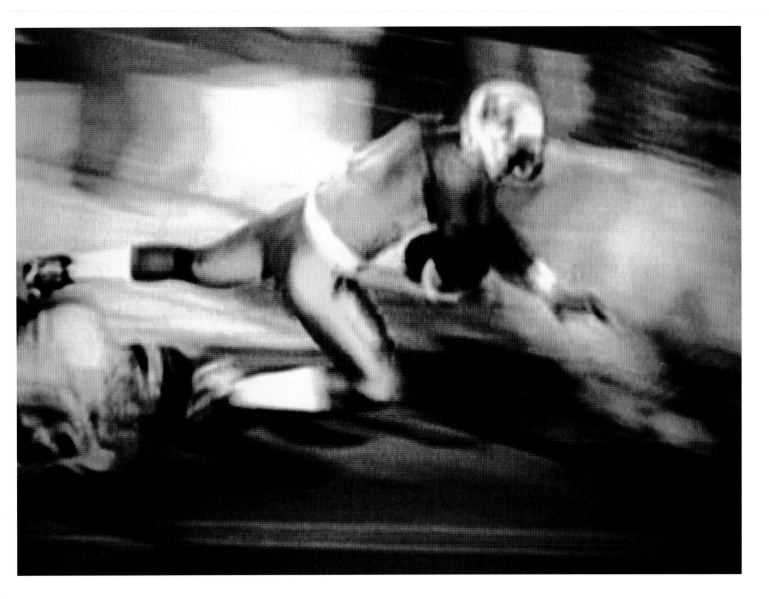

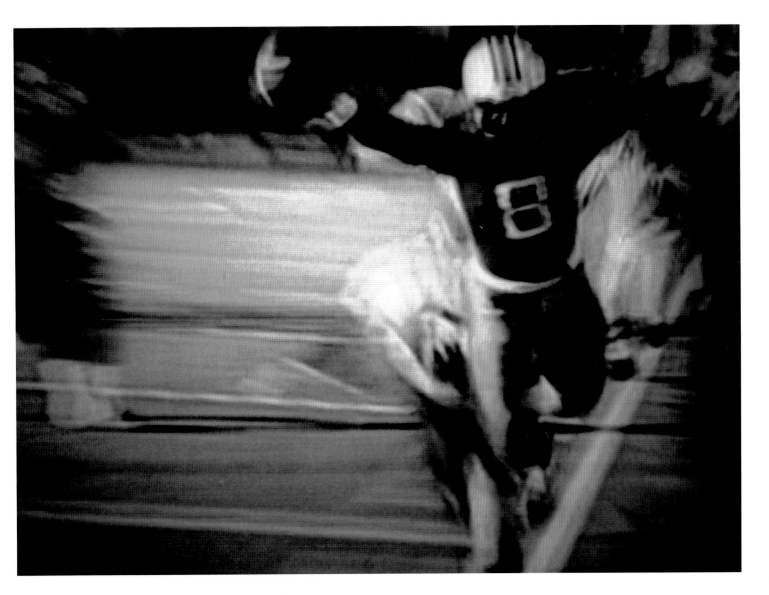

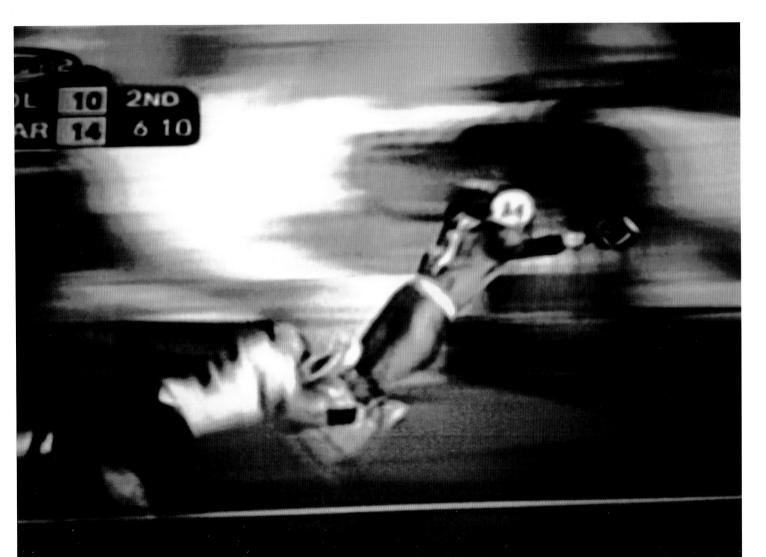

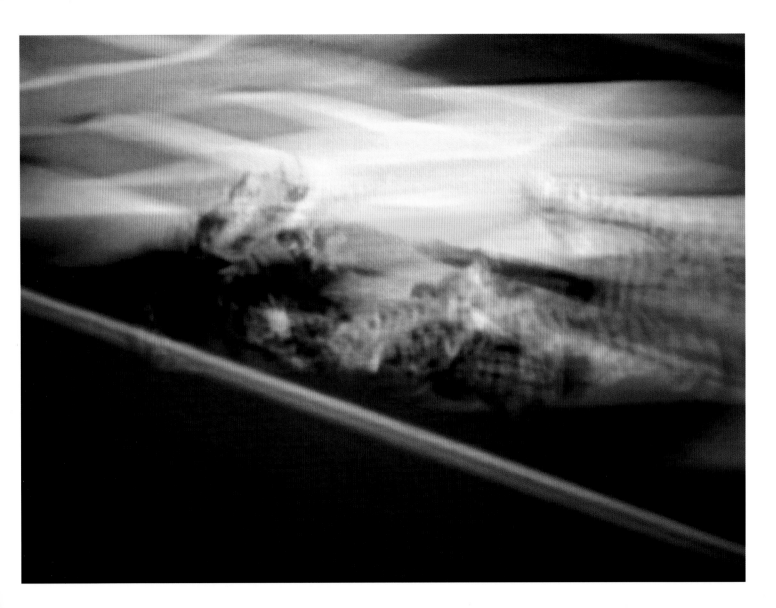

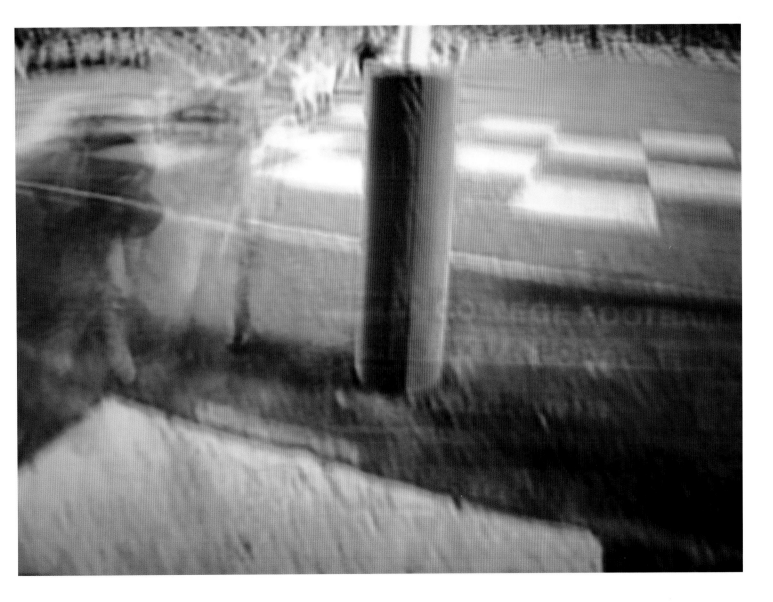

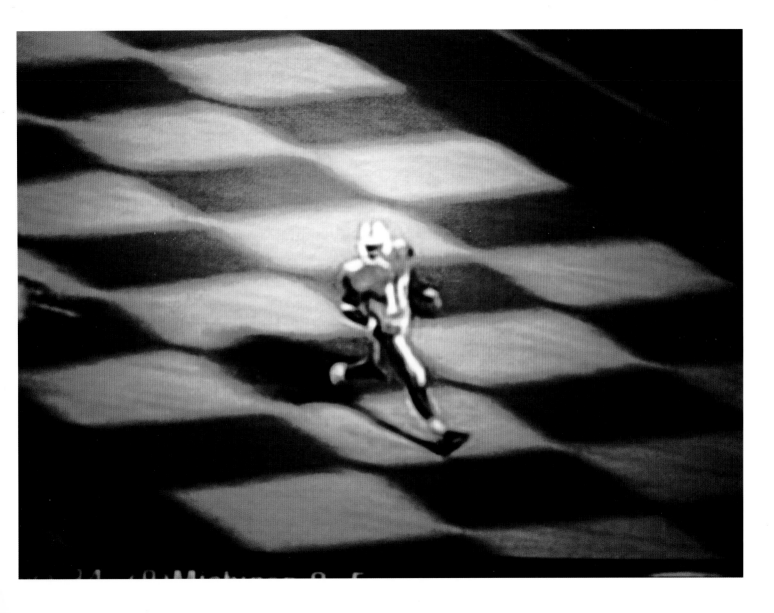

Ghostplay
© 2005 powerHouse Cultural Entertainment, Inc.
Photographs © 2005 Eric Payson

Published in the United States by powerHouse Books,
a division of powerHouse Cultural Entertainment, Inc.
68 Charlton Street, New York, NY 10014-4601
telephone 212 604 9074, fax 212 366 5247
e-mail: ghostplay@powerHouseBooks.com
website: www.powerHouseBooks.com

First edition, 2005

Library of Congress Cataloging-in-Publication Data:
 Ghostplay / photographs by Eric Payson ; edited by Mark Holborn.-- 1st ed.
 p. cm.
 ISBN 1-57687-271-8
 1. Football--United States--Pictorial works. 2. College sports--United
States--Pictorial works. 3. Television broadcasting of sports. I. Holborn,
Mark, 1949-
GV951.G46 2005
796.04'3'0222--dc22
 2005048901
Hardcover ISBN 1-57687-271-8

Publication Director: Peter C. Jones
Publication Associate: Hayley Graham
Digital separations by Ronn Spencer and Blake Hines, Sole Studio, Tucson
Printing and binding by Lotus Printing, Inc.

Edited and designed by Design Holborn, London

A complete catalog of powerHouse Books and Limited Editions is available upon request;
please call, write, or tackle our website.

10 9 8 7 6 5 4 3 2 1
Printed and bound in Hong Kong